KNUTSFORD
HISTORY TOUR

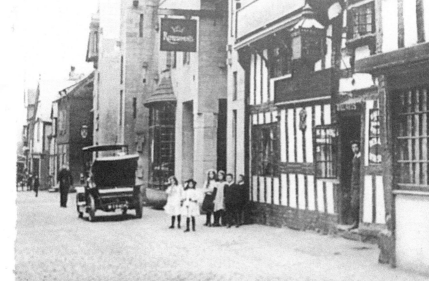

First published 2017

Amberley Publishing
The Hill, Stroud,
Gloucestershire, GL5 4EP
www.amberley-books.com

Copyright © Paul Hurley, 2017
Map contains Ordnance Survey data
© Crown copyright and database right
[2017]

ISBN 978 1 4456 6880 2 (print)
ISBN 978 1 4456 6881 9 (ebook)

British Library Cataloguing in
Publication Data.
A catalogue record for this book is
available from the British Library.

Origination by Amberley Publishing.
Printed in Great Britain.

INTRODUCTION

Knutsford is an ancient town with an interesting history and some quite extraordinary buildings. In common with other nearby North Cheshire towns, Knutsford has its quota of wealthy inhabitants. Accordingly, there are many high-class shops and restaurants. King Street is the lower, or bottom, one-way street through the town centre, while Princess Street, running parallel (also one-way), is at the top. More details can be found within some of the interesting buildings in the town centre, but two worthy of mention are the Gaskell Memorial Tower and the Kings Coffee House next door. Gaskell Memorial Tower was built in honour of the famous Knutsford author Elizabeth Cleghorn Gaskell, who used the town and its characters in her novels including *Cranford*, which became a successful TV series. Both were built by the somewhat eccentric Richard Harding Watt in 1907/8. The many buildings of Watt, a Manchester glove maker, are a strange addition to this pretty Cheshire market town. He was well travelled and decided to bring some of the ideas from the countries he visited and replicate them in Knutsford. Legh Road has many of his creations in the form of Italianate dwelling houses. He also built the large laundry and Ruskin Rooms in Drury Lane, off King Street; this time he included some Moorish influences with minarets, domes and towers. Not everyone in Knutsford was enamoured with these fantastic buildings at the time; Nicholas Pevsner, the noted architectural historian, described the creations as 'the maddest sequence of villas in England!'

The home of Elizabeth Gaskell can be found in the street named after her, Gaskell Avenue, and further down this short road is Heath House, where Highwayman Edward Higgins (or 'Squire' Higgins as he was known) once lived. The same house in 1741 was occupied by Mr Charles Cholmondeley, a

well-known Cheshire personage. It was also known at one time as the 'Cann Office' as it was where scales and weights were tested.

Going back a little further, the town is mentioned in the Domesday Book and although there are many different suggestions as to the name Knutsford, it would appear that King Canute features quite strongly. One unusual local tradition is to 'sand' the streets for weddings and other functions. Tradition has it that this originated when Canute, after fording the river, shook the sand from his shoes in the path of a wedding party. This tradition is now carried out during the Knutsford May Day or, should I say, the Royal Knutsford May Day, as it is allowed to use 'Royal' in its title. This honour was bestowed on the event by the Prince and Princess of Wales in 1887, who would later become Edward VII and Queen Alexandra. This procession leads to Knutsford Heath, a large grassed area in the town that once boasted the Knutsford Racecourse with its intricate grandstand.

The large Knutsford Prison can also be found in the town, which was fronted by the still extant Sessions House (both were built 1817–18). The prison existed through the very draconian sentencing that prevailed in the 1800s – transportation for six years for a minor theft was not unusual, and the prisoners were housed there prior to this. Eventually there was accommodation for up to 700 prisoners and the prison was equipped with a gallows, treadmill, birch, cat o'nine tails and crank machine for punishment. The prison went on to be a military detention centre and spent a time as a training centre under Revd Tubby Clayton of Toc H fame, who for a short time trained ex-servicemen for ordination. The buildings were used to house homeless families after the First World War and were demolished in 1934, albeit the sessions house later became Knutsford Crown Court.

Another attraction not to be missed is the Penny Farthing Museum, situated in the courtyard of the Coffee House and restaurant at the rear of No. 92 King Street.

This has been merely a taste of what can be found in the book, so enjoy learning more as you explore this gem of a Cheshire town.

KEY

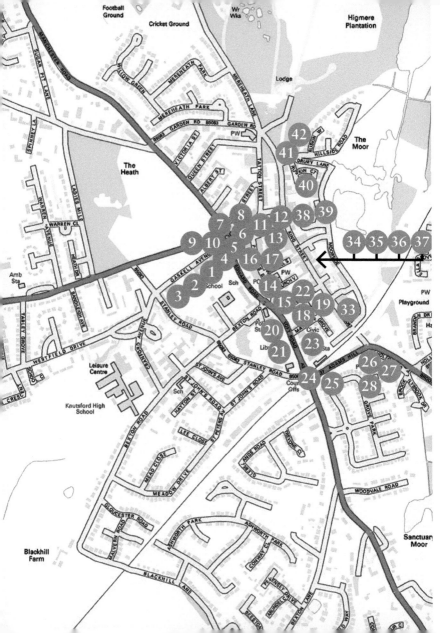

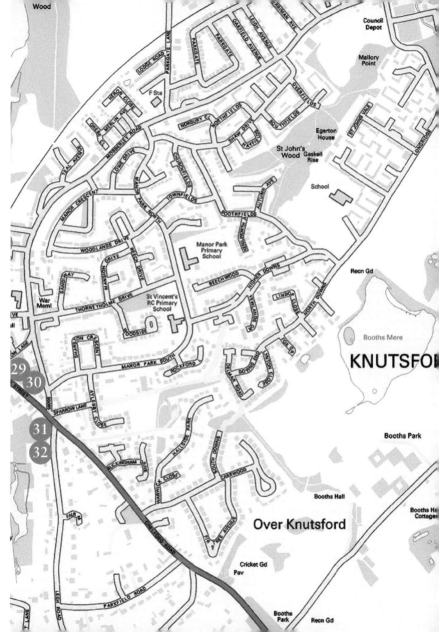

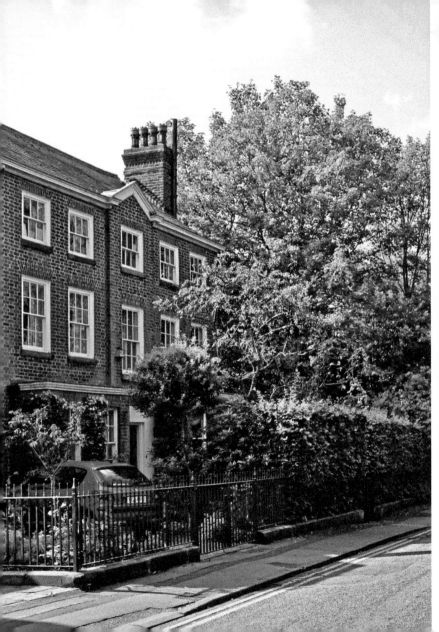

1. GASKELL AVENUE, UNDATED

We start our walk through the town in the middle of Gaskell Avenue, which was originally called Heathside since it runs along the side of the small heath as opposed to The Heath, now better known as Knutsford Heath, which is far bigger and on the other side of Northwich Road. Mrs Gaskell's house can be seen on the left of this undated image. As a tribute to this esteemed local author, the road was renamed Gaskell Avenue after her death on 12 November 1865.

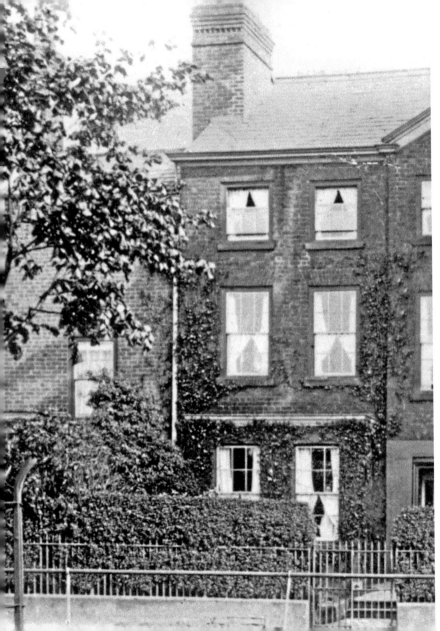

2. HEATHWAITE HOUSE, 1900s

Still in Gaskell Avenue, we come to Heathwaite House, which was once occupied by Elizabeth Cleghorn Gaskell, who was born in Lindsay Row, Chelsea, in 1810. (This house still exists as No. 93 Cheyne Walk, London). She lived here in Knutsford with her aunt Hannah Lumb shortly after her birth (her mother died three months after she was born) until the age of eleven when she went to boarding school in Stratford upon Avon. An accomplished and famous author, she loved Knutsford and depicted the town in her fictional novels, one name being Cranford, which went on to be a TV series, another being Hollingford in *Wives and Daughters*. Her time living in the town ended when she married William Gaskell in 1832, an assistant minister in Cross St Unitarian Chapel, Manchester. She had an impressive circle of friends including Charlotte Brontë, John Ruskin and Florence Nightingale. Even Charles Dickens was an associate. She died suddenly in 1865 while negotiating the purchase of a house in Hampshire. Mrs Gaskell, as she became known, is buried with her husband in the graveyard at Knutsford's nearby Brook Street Chapel. There is a plaque on the Gaskell Avenue house.

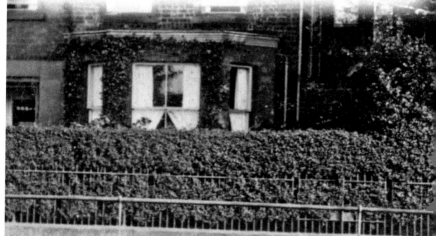

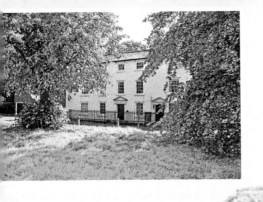

3. HOME OF HIGHWAYMAN HIGGINS

Carrying on now from the home of Mrs Gaskell, we come to another property that is perhaps a little more infamous as this large house on Gaskell Avenue was the home for many years of Edward Higgins, or Highwayman Higgins. He was known as Squire Higgins to his friends and the local gentry, who believed him to be one of them. In 1754 he had been transported to America for seven years for housebreaking in Worcester. Within a few months of arriving in America, he stole a large amount of money from a house, then returned in 1756 and bought this property in Knutsford. He was married and fathered five children. By day he was a member of the gentry: he would attend parties (and steal while he was there), shoot, and ride in the hunt. He did own other properties and his wife and friends thought that his frequent disappearances were to collect rent. By night, however, he was a burglar and highwayman. He was caught in Carmarthen and hung there on 7 November 1767.

The house is still there in Gaskell Avenue (*see* inset) and was mentioned in Mrs Gaskell's *The Squires Story*, which was loosely based on the antics of the rogue who lived here.

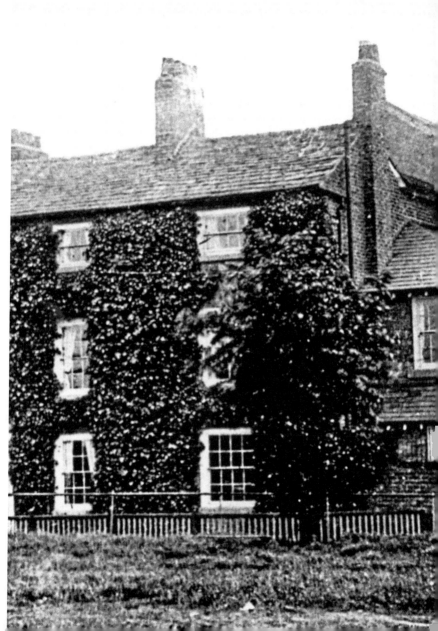

4. CANUTE PLACE JUNCTION, 1950s

Walking now to the town end of Gaskell Avenue, we come to King Edward Road. It opened in 1937 and was named after the short-lived Edward VIII; it is now part of the A50, running parallel with Princess Street and joining Toft Road further on. As we cross this road, in front of us we can see one of Knutsford's most famous landmarks standing on what is now a busy roundabout: The White Bear Inn.

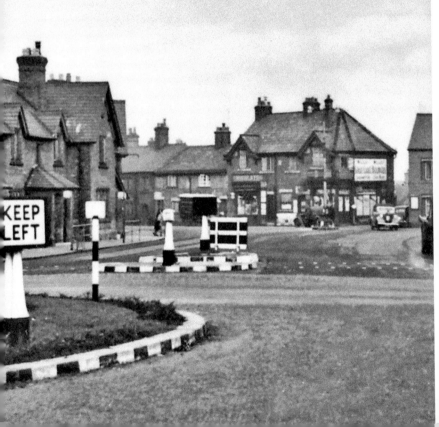

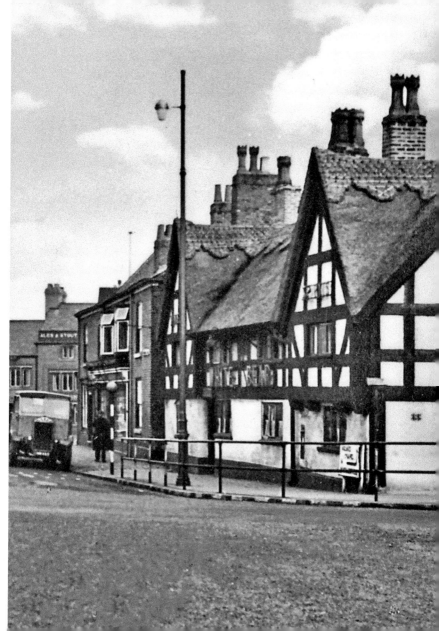

5. THE WHITE BEAR, 1910

The ancient White Bear public house is on the corner of Canute Place. This seventeenth-century pub was extensively altered on the front elevation in the late 1800s. Prior to this it was timber-framed and of simple brick construction, and is now rendered in mock timberwork and is Grade II listed.

After the Second World War the attractive thatched roof caught fire. Fortunately the option of replacing the roof with cheaper tiles was not taken and what we have is a beautiful black-and-white thatched building to welcome visitors to Knutsford. In olden times this pub was in Heathside, now Gaskell Avenue.

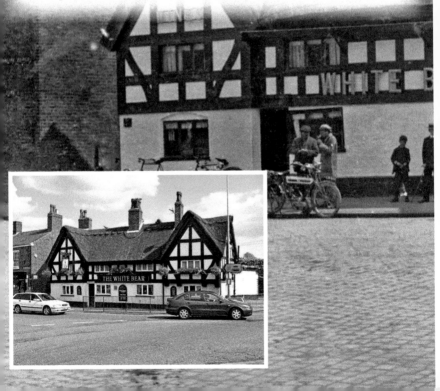

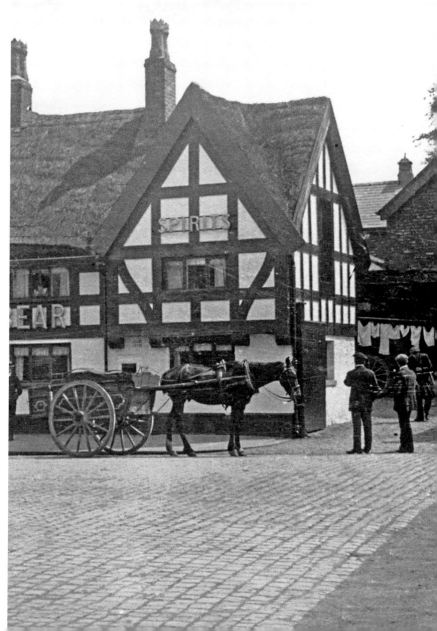

6. CANUTE SQUARE, 1960s

The road here has been altered and the road sign on the photo is on one of the iron lamp standards – one of five erected in 1844 by the Freeholders of Nether Knutsford. They remained unconnected and unlit by gas for many years, all but one being removed in the 1960s. The period cars here illustrate how things change over the years.

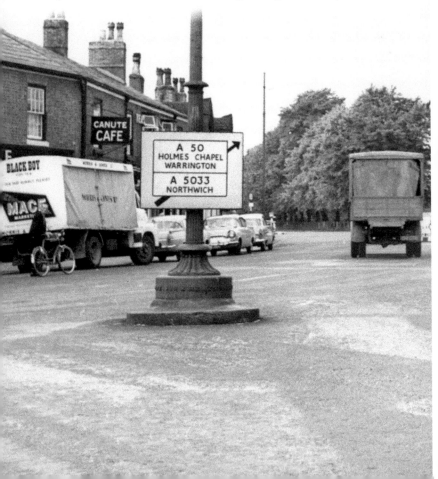

7. CANUTE SQUARE, EARLY 1900s

If we look in the opposite direction towards Tatton Street, we see the newsagents on the right. This store is still there, albeit the many period advertisements have gone. Quite a few of the buildings and cottages have resisted development in the intervening years.

The inset image (2017) shows Canute Square today. The side of the road with the newsagents has changed little but opposite is a different matter.

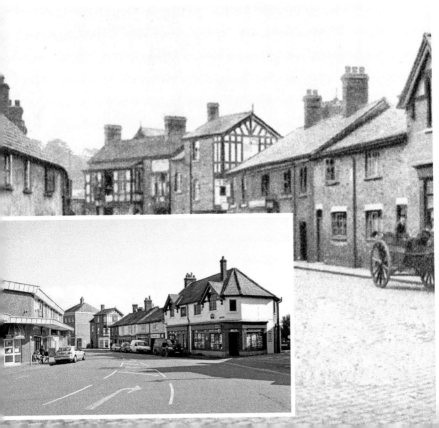

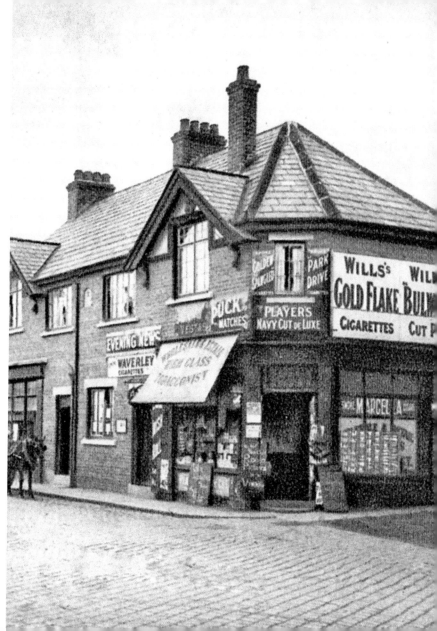

8. CANUTE SQUARE/TATTON STREET, LATE 1800s

Back even further now to before the newsagents was built and thatched cottages abound. The white cottage on the left was the Feathers Inn, which reverted to a cottage in 1910 and lost its thatched roof at around the same time, as can be seen in the previous old photograph. During the 1800s, Canute Place was often used as a small open-air livestock market.

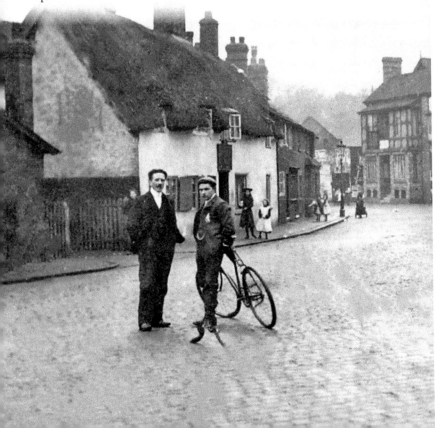

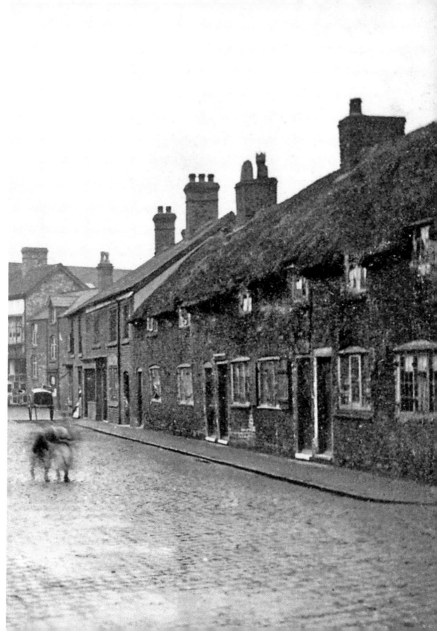

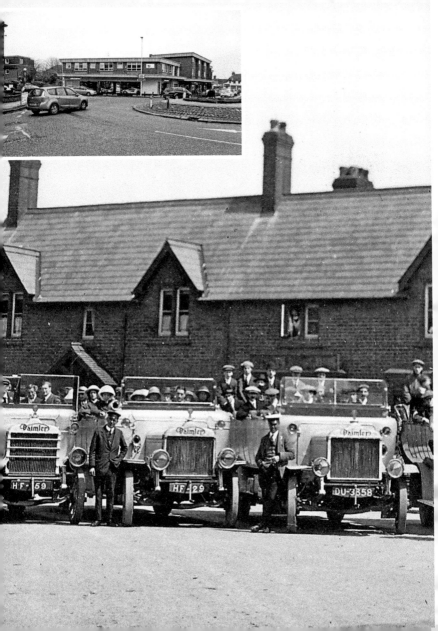

9. CORNER BUILDING, 1910–20

A last few looks at the Canute Square area, this time we'll visit the roundabout. This shows the shop that stood on the corner of Canute Square, and the White Bear is still on the opposite corner. Lined up in front of the shop a number of Daimler charabancs can be seen that will be leaving for a day trip to the seaside.

The modern inset photo is of the building that has taken its place and now houses a very prestigious car showroom.

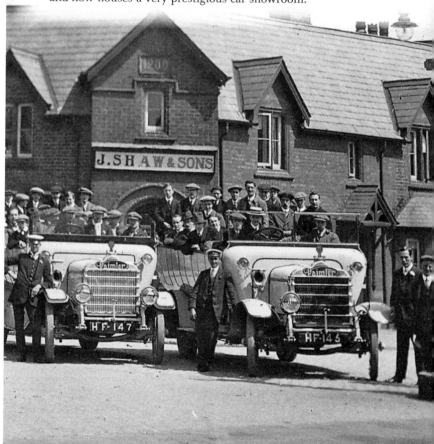

10. MCDOWELL'S STORE, 1960s

Local historian Fred McDowell has provided many of the old photographs in the book and this old photograph is of his father's store when it occupied the building; his father can be seen in the doorway.

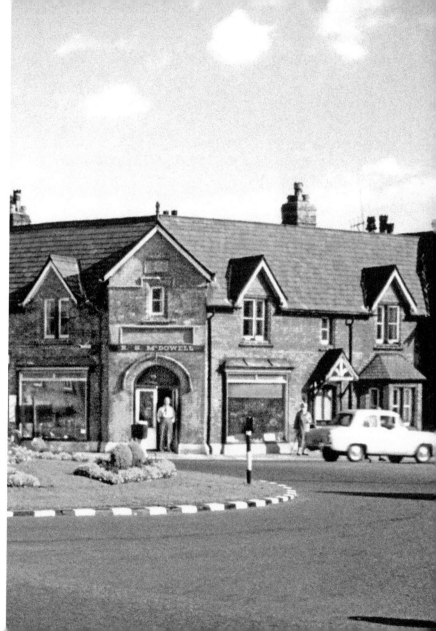

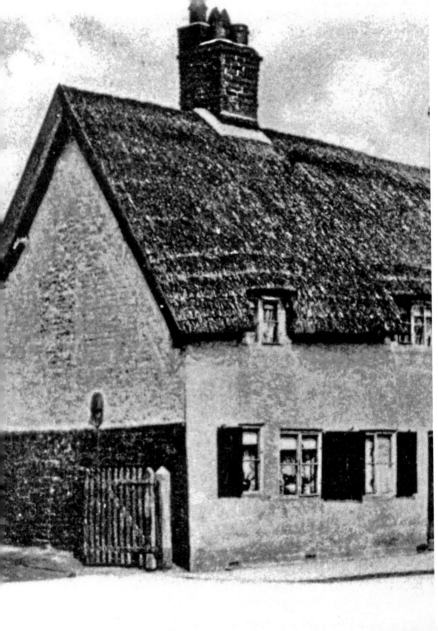

11. OLD COTTAGES, TATTON STREET, 1903

Passing through Canute Place, an area that is now quite busy traffic-wise, and into Tatton Street, where we get a better view of the old thatched cottages that in this photograph house the Feathers Inn. The Lord Eldon can be seen on the far right, which now sits rather incongruously between modern buildings.

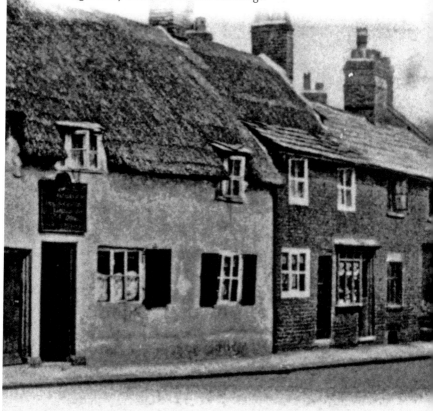

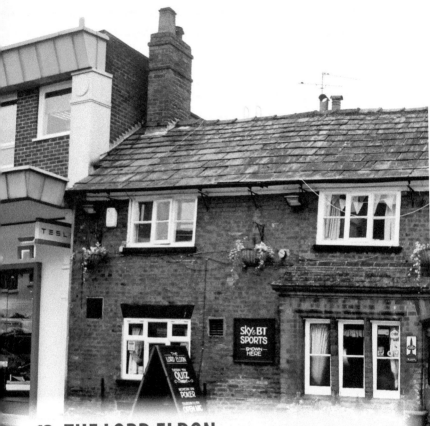

12. THE LORD ELDON

This popular pub, believed to be the oldest in the town, is around 300 years old and has changed little over the intervening years – we cannot say that for the old Feathers Inn!

At a time when pubs are fast disappearing or being turned into modern drinking and eating palaces, the Lord Eldon has bucked the trend and altered little since those distant days. Small, cosy rooms can be found within and it makes a most pleasant place to while away a few hours, just as customers have done there for 300 years.

13. TATTON STREET, LATE 1800s

A last look at this part of the town. This old photo is taken in the days when the photographer could spend half an hour in the middle of the road. That no longer applies, but then cameras are not so big! What must it have been like in those cottages, they look so cosy, but perhaps those living there would not have agreed with that description. The two pubs stand side by side – the Feathers Inn and the Lord Eldon.

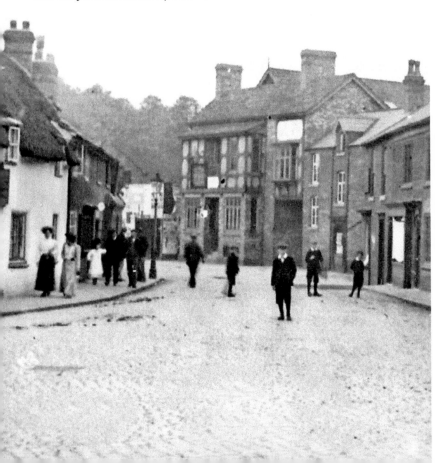

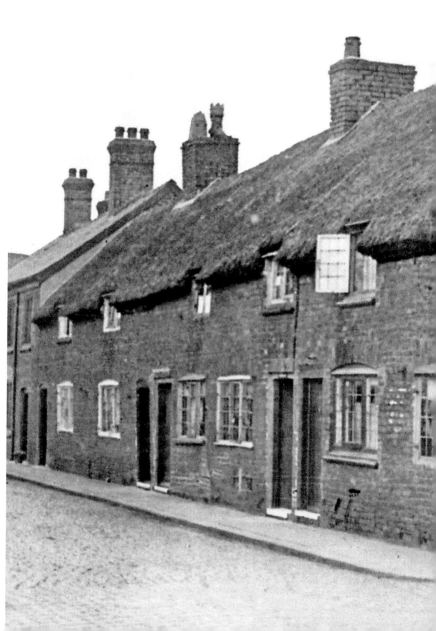

14. PRINCESS STREET, 1865

Walking now from the roundabout along King Edward Road towards Toft Road, we come to the end of Princess Street, opposite the police station. This is the oldest photograph in the book. As we look into Princess Street from Toft Road in 1865, the ladies can be seen looking from the gable-end window and on the left are the Hollands, cousins of Elizabeth Gaskell. The man and boy in the centre of the road are Tom Lee and his son Robert. Photography was still in its infancy at the time this was taken.

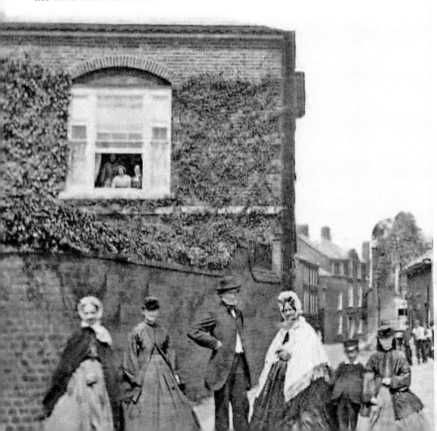

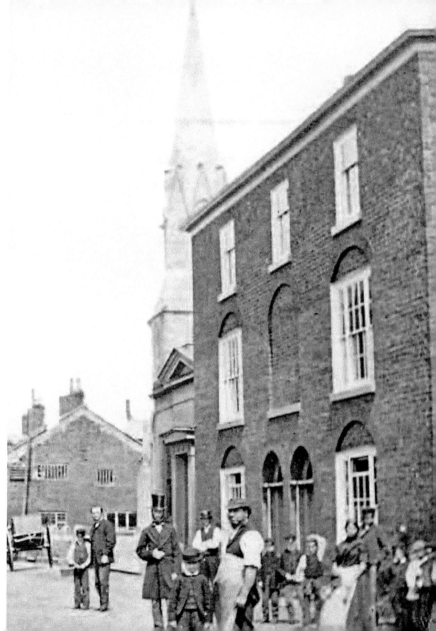

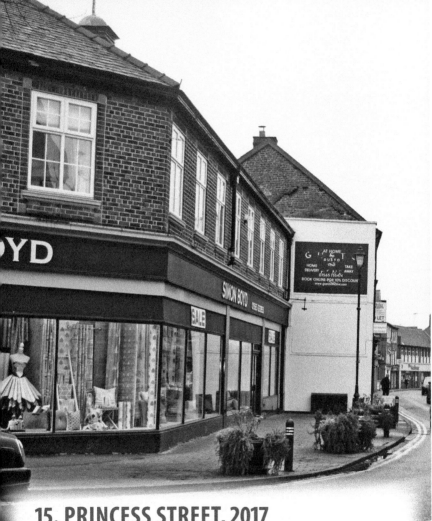

15. PRINCESS STREET, 2017

A later look now from Toft Road into Princess Street, The church spire that had suffered damage in a gale in June 1914 was found to be dangerous and was demolished in 1949.

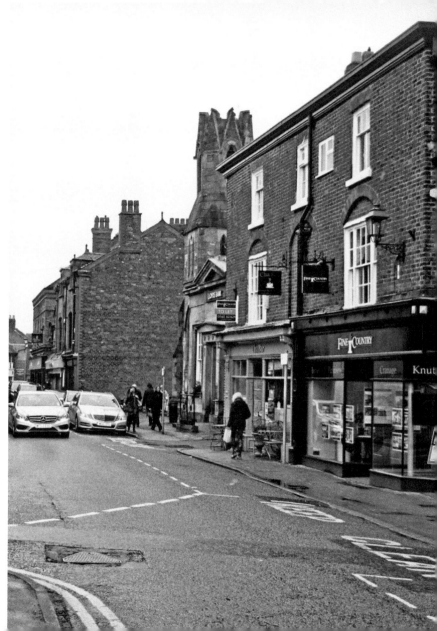

16. PRINCESS STREET, 1890–99

Continuing now into Princess Street, we can see the Royal George Tap. It was part of the Royal George Hotel in King Street. The hotel was one of Knutsford's most prestigious and while the gentry would enjoy the facilities in the main hotel, their staff – in the form of butlers, valets, carriage drivers and the like – would enjoy the rougher facilities in the Tap. Now a modern bar, little in the way of architecture has changed, on that side of the road anyway.

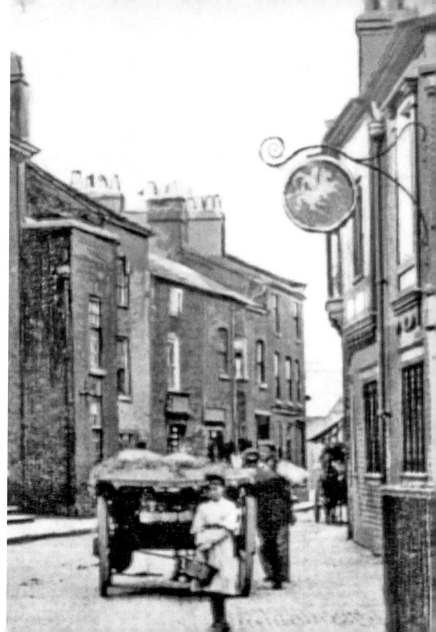

17. PRINCESS STREET, 2017

As we compare this modern shot with the old one, we see just how busy this modern road is. But consider the fact that before King Edward Road was built, this was the main road through the town; it continued into Toft Road and onwards to Manchester (or Holmes Chapel the other way).

18. TOWN HALL, 1920s TO '30s

Turning now and walking back along Princess Street to the Toft Road Junction, we find Knutsford Town Hall. This beautiful building was built in 1872 by Lord Egerton of Tatton and designed by Alfred Waterhouse, who was also responsible for, among other buildings, Manchester Town Hall and the Natural History Museum in Kensington. Originally it had a market hall on the ground floor and at this time the archways were open in typical market architecture. There was a concert hall on the second floor with seating for 400 persons. The arches have since been filled in and it now houses a restaurant called The L&F (Lost and Found).

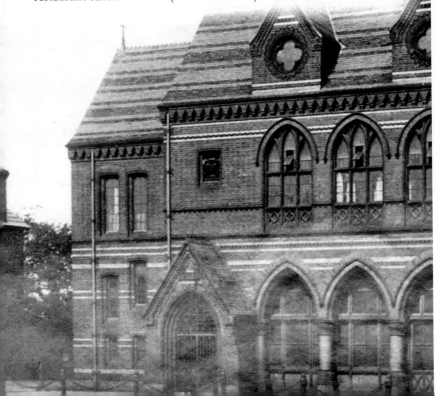

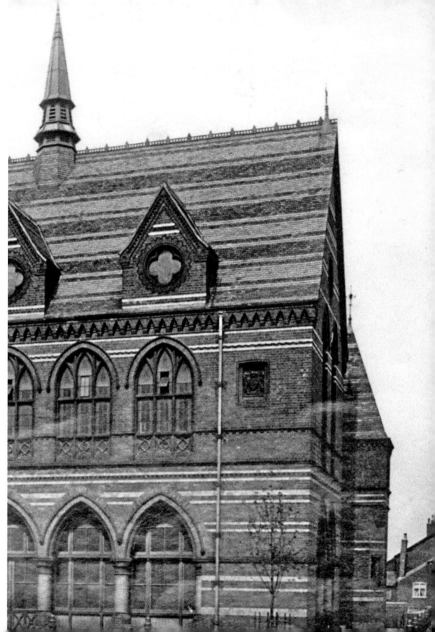

19. TOWN HALL, 2017

The Town Hall is mentioned in assorted books covering the life of General Patton and his so-called 'Knutsford Incident' as the location of this speech. In the film *Patton*, the speech took place on the Town Hall steps. In a biography it took place in the grounds of Peover Hall where General Patton was based. I have found one reference to the speech being in the grounds of the Ruskin Rooms where the actual officers' club was going to be sited. He was invited to open a club as a 'Welcome Club' for officers and he was not due to say anything but was invited to do so. He made an off-the-cuff speech, often misquoted around the world. It was said that he snubbed the Russians. This was known as the 'Knutsford Incident' and damaged his career in the short term.

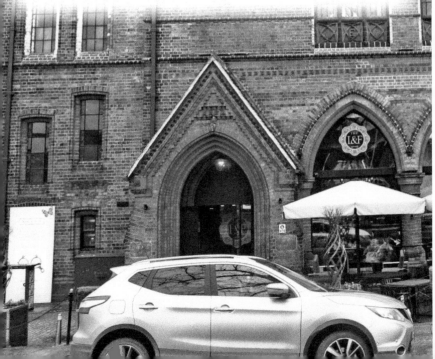

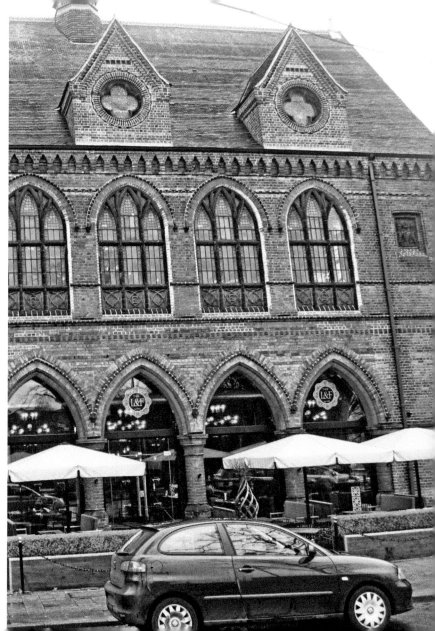

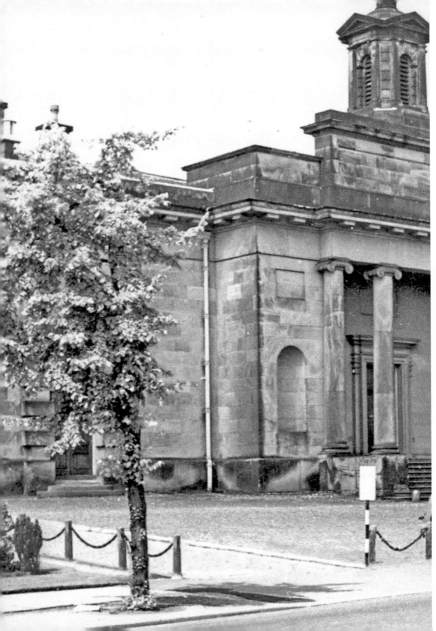

20. TOFT ROAD, 1920s

We now look across Toft Road. In the photograph here it was joined to Princess Street; King Edward Road had not yet been constructed. The large building at this location was Knutsford Crown Court. In 1920 it was known as the Session House, which fronted Knutsford Prison – both were built in 1818. This was a large prison with accommodation for up to 700 prisoners. It opened in around 1820 when Chester Prison reached capacity. It remained so for over 100 years and during this time it held, among many others, Chartist prisoners and IRA men from the 1916 uprising. It later became a military detention centre and a Toc H training school.

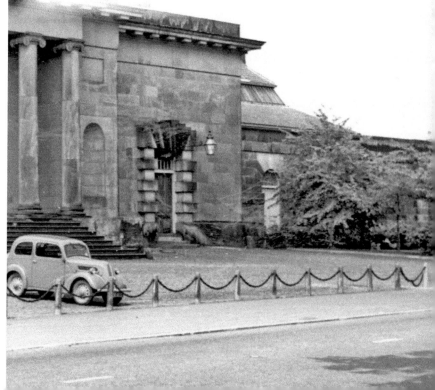

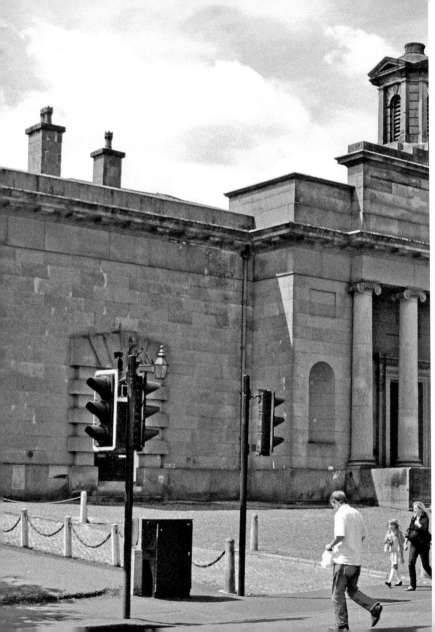

21. KNUTSFORD CROWN COURT BUILDING

The massive prison was finally closed in 1934. It was demolished, and over the years the grounds became a park, supermarket and bus station. The Crown Court remained as a standalone Grade II-listed building. In May 2010 it saw its last trial, before its duties were moved to the Crown Courts in Chester and Warrington. Since closing it has been taken in hand by the Cheshire hoteliers, Flat Cap Hotels, who embarked on a full restoration to turn this beautiful building into a hotel, restaurants and conference centre called, appropriately, The Courthouse.

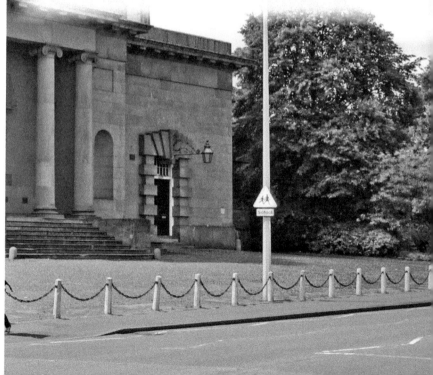

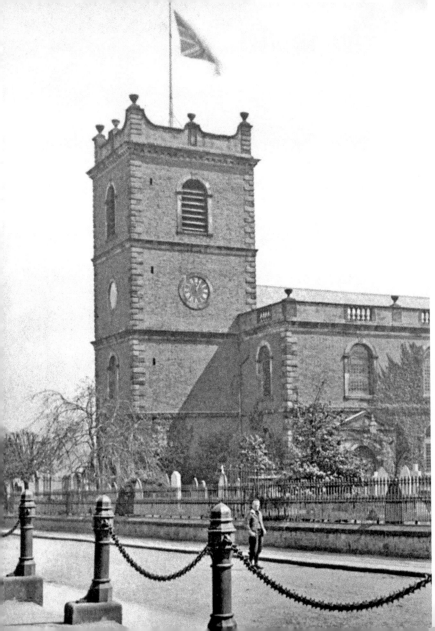

22. KNUTSFORD PARISH CHURCH, 1902

Standing now in Toft Road at the top of Church Hill, at the side of the Town Hall we view the Parish Church of St John the Baptist. Until the eighteenth century this was a chapel of ease in the parish of St Mary's at Rostherne. This building was built between 1741 and 1744 and became a parish in its own right.

This ancient parish church was formerly dedicated to St Helena and originally served the townships of Bexton, Knutsford Nether, Ollerton, Knutsford Over and Toft. The parish register can be traced back to 1581. As can be seen in the inset image, it's another case of the lovely ornamental railings going for use in the war effort.

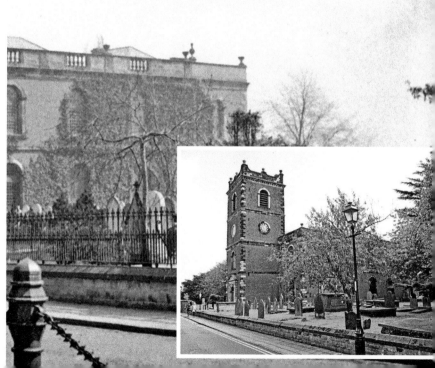

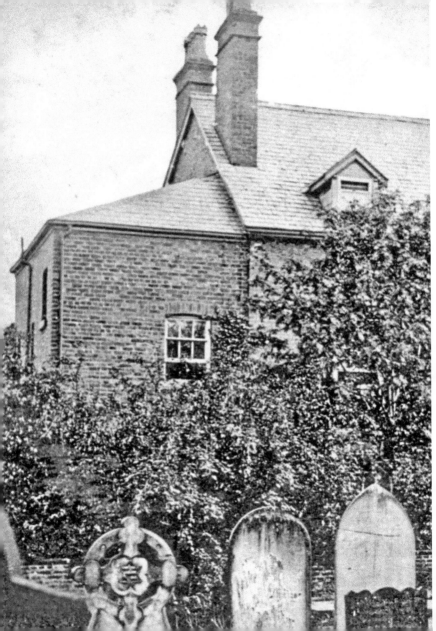

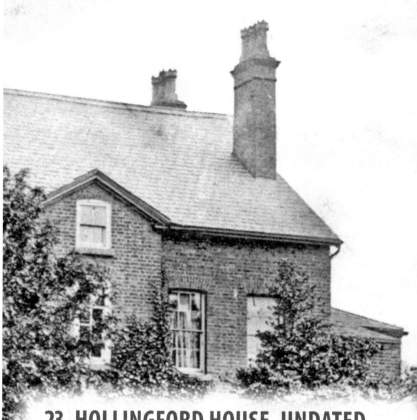

23. HOLLINGFORD HOUSE, UNDATED

With Knutsford being the setting for Elizabeth Gaskell's books, it goes without saying that a lot of the older properties will have been used in them too. This house on the edge of the graveyard is now a shop's premises, but it was used by Mrs Gaskell in her novel *Wives and Daughters*. It was depicted as the home of Dr Gibson, father of Molly, in the small town of Hollingford. This was Mrs Gaskell's last novel.

24. RAILWAY LINE, 1912

Here we look over the bridge parapet from Toft Road down onto Knutsford Railway Station. This line was part of the Cheshire Lines Committee (CLC) and was opened on 12 May 1862 with services from Knutsford to Altrincham. In 1863 the line was extended to Northwich in the opposite direction. Note the quite extensive goods yards on both sides of the platforms and the small engine shed at the end.

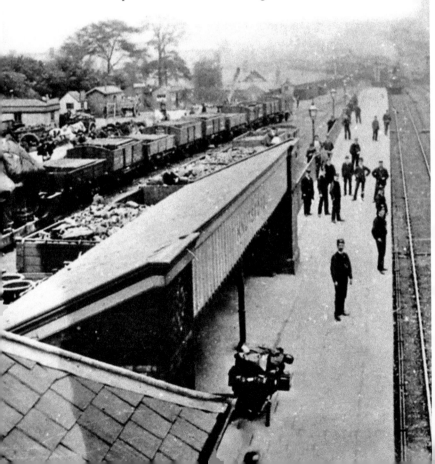

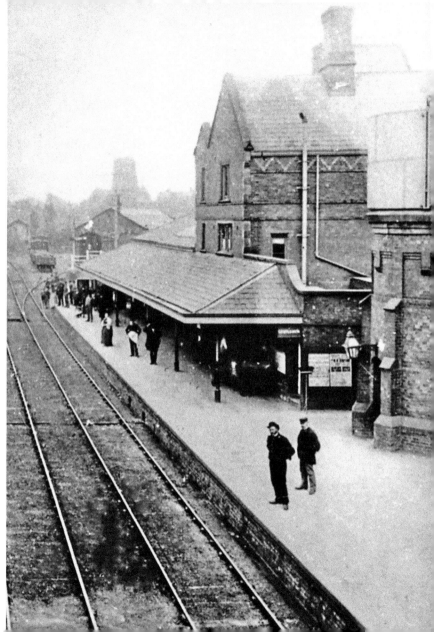

25. ADAMS HILL, 1926

Leaving the bridge over the railway, we walk along Toft Road to a junction with Adams Hill, on the left. Looking down the road, we see the vehicular access to Knutsford Railway Station on the left. The tower of St Cross Church in Mobberley Road can be seen above the library at the bottom. This Free Library building was built in 1904 in the Gothic style. It was funded by the Carnegie Trust and is now a children's day nursery.

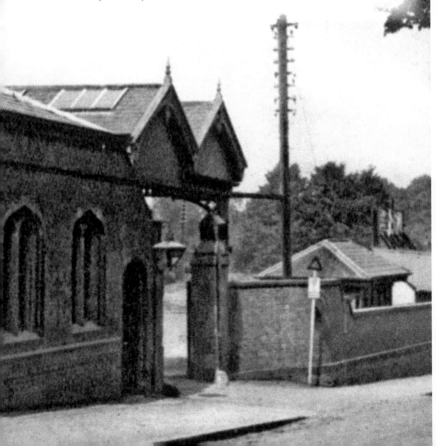

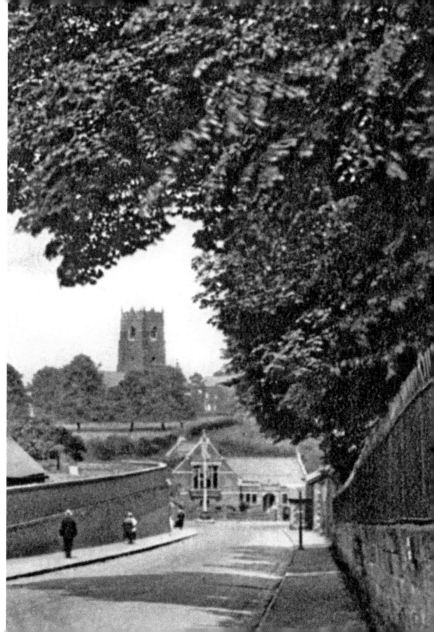

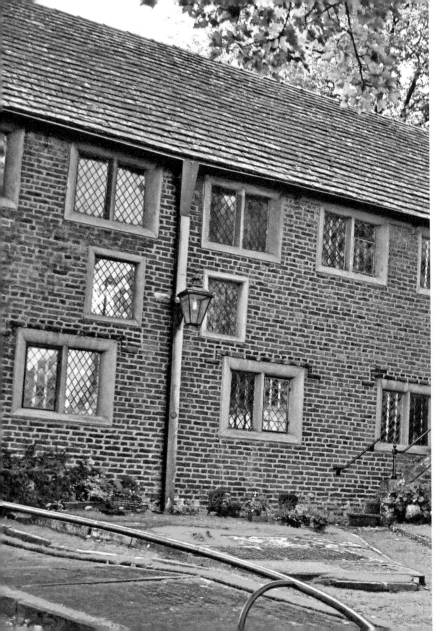

26. UNITARIAN CHAPEL, UNDATED

Walking down Adams Hill, we reach King Street on the left, but we will pass it for now and return later. Around the bend we find Brook Street Chapel, built shortly after 1689. Prior to this date the laws of the land discriminated against so-called Dissenters – those who followed religions other than the Church of England, such as Baptists and, as in this case, Unitarians (but not Catholics). The law was changed as a result of the Act of Toleration in 1689, which gave permission for the faithful to worship in their own chapels and churches. Elizabeth Gaskell and her family worshipped here and her grave is in the churchyard.

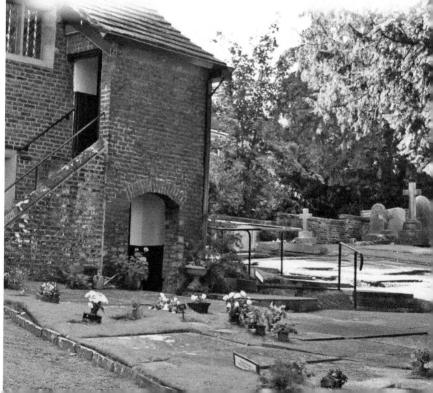

27. UNITARIAN CHAPEL, UNDATED

Here we have a postcard view of this pretty chapel; it contains a picture of Elizabeth Gaskell, whose grave is marked by the small cross. The date is given as 1688, which, unless the chapel was built illegally, is incorrect. From 1827–72 Henry Green was the minister and in 1857 he wrote *Knutsford: Its Traditions and History with Reminiscences, Anecdotes and Notices of the Neighbourhood*. This was reprinted in 2009. Mention is also made on the postcard of the chapel featuring in her book *Ruth*.

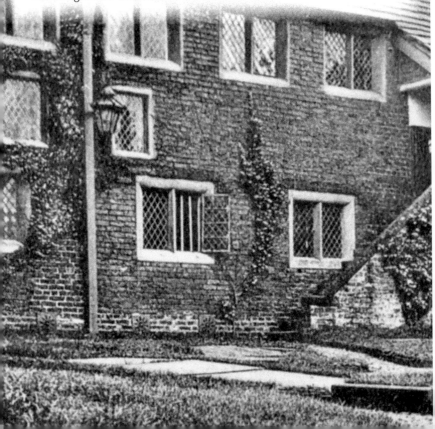

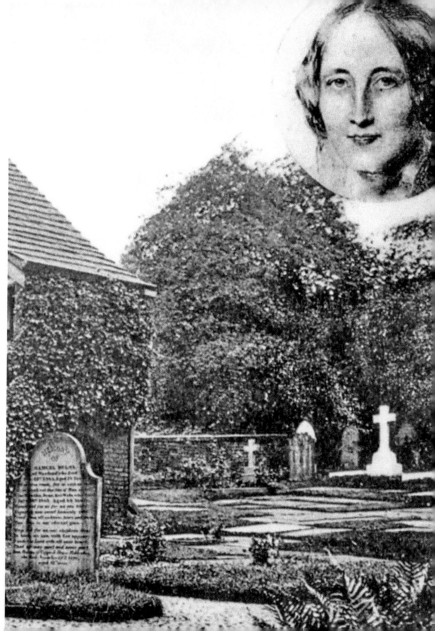

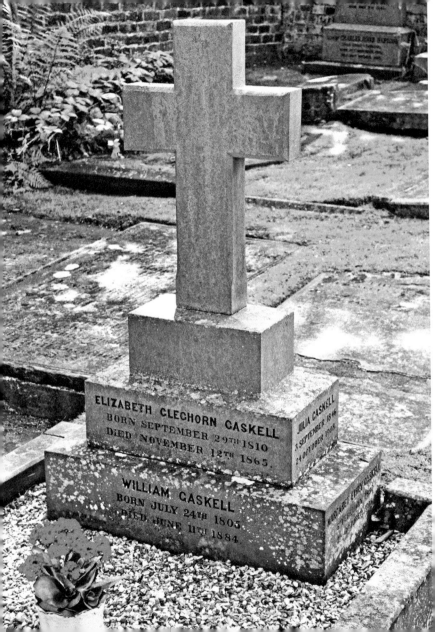

28. ELIZABETH GASKELL'S GRAVE

The actual grave of the popular Knutsford author, who died at fifty-five years of age. She was born in Chelsea and grew up in Knutsford, but moved to No. 42 Plymouth Grove in Manchester (now No. 84) with her husband William, a Unitarian minister, author and campaigner on behalf of the poor. Her books were written there and visits were made by the likes of John Ruskin and Charlotte Brontë (whose biography she wrote). Elizabeth's husband, William, and their two unmarried daughters are buried with her.

We leave the chapel and continue along Brook Street and up the hill towards Chelford.

29. THOMPSONS' STORE

This highly decorated store stands at the junction with Mobberley Road. The date of 1881 is engraved on one of the black beams and the wording, which has been renovated, says, 'Think of ease but work on. No gains without pains.' Underneath the windows it says, 'Great business must be wrought today our mission is to serve, yours to quickly buy and we'll do our part full well – if you'l [*sic*] only let us try.' The shop went on to become the village store and post office; the postbox can be seen in this modern photo.

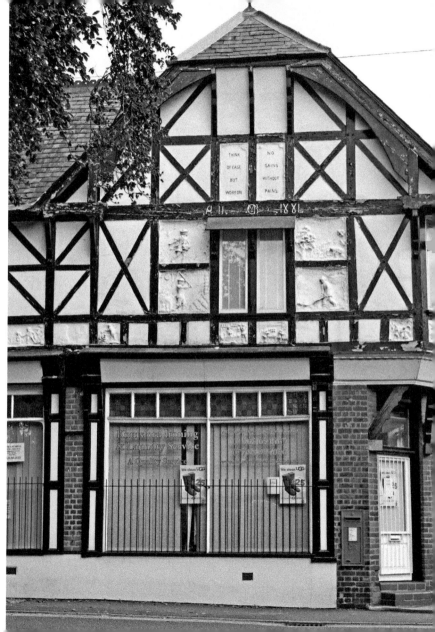

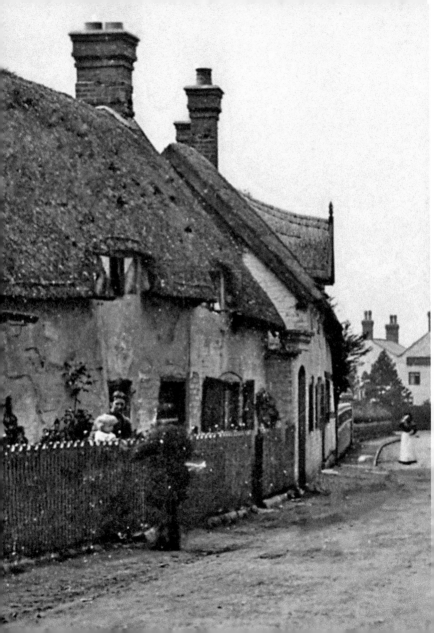

30. CHELFORD ROAD, TOWARDS TOWN, LATE 1800s

We carry on now as the road changes its name from Brook Street to Chelford Road, and we stop and look back towards the Legh Arms pub. The cottages on the left have now been swept away to make way for high-class and set-back dwelling houses. The spire in the distance is of the Independent Congregational Church, which was built in 1866 with the manse and schoolroom, but was closed in the 1920s and demolished in 1938. This road was depicted in Mrs Gaskell's novel *Cranford* as Darkness Lane.

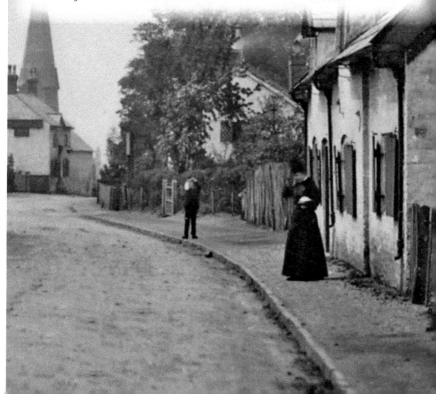

31. LEGH ROAD

Now for the reason we have climbed the hill: alongside the Legh Arms is Legh Road, which must boast the rarest set of houses in Cheshire, if not the whole country. Richard Harding Watt was a glove maker in Manchester and made his fortune in this enterprise. He was not an architect but was well travelled and he chose Knutsford to live out his architectural fancies and bring them to life. Legh Road is where he built his own house, The Croft (now The Old Croft), in 1895, which was quite conventional, but he then took his fantasies further elsewhere.

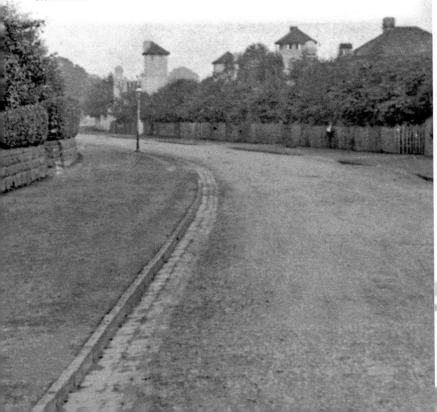

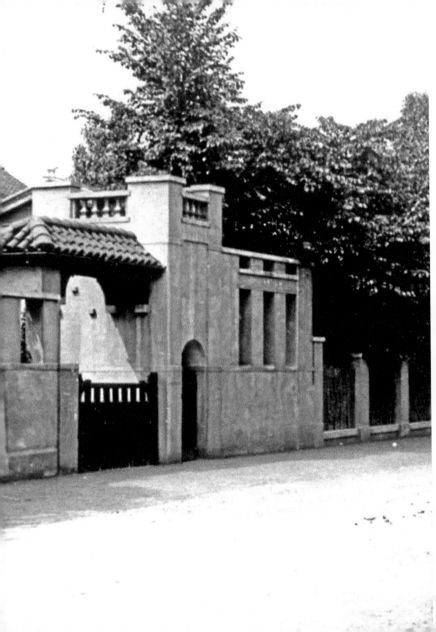

32. LEGH ROAD, EARLY 1900s

Still in Legh Road, we see the gatehouse of one of Watt's exotic creations. The houses are built in styles reminiscent of Italian villas, certainly not a style one would expect in an English country town, and he was subjected to some ridicule at the time. Though the houses are popular and the road quite exclusive, when Steven Spielberg made *Empire of the Sun*, he used Legh Road for some scenes depicting old Shanghai. When we return to the town centre, we will see further examples of his unique buildings.

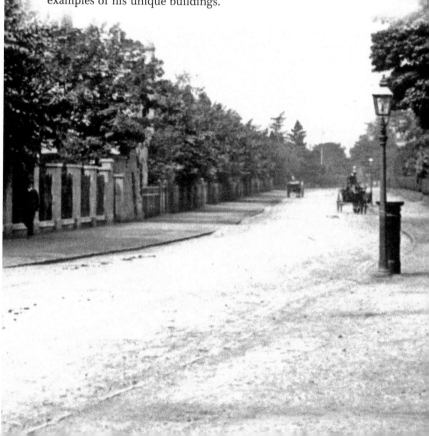

33. TUDOR COTTAGES, KING STREET, 1940–49

As promised, we now turn into King Street and walk under the railway bridge into this ancient street. After carrying on for a way, we reach some beautiful black-and-white cottages on the left. We turn the clock back to the war years when we turn to look at them. In the image here, period cars and trucks are visible and the old black-and-white cottages can clearly be seen on the right.

Taking a more detailed look at these ancient cottages, we see in the inset image that they have been modernised but still retain their charm. What a pity that this treatment could not have been used elsewhere instead of ugly buildings replacing charming cottages that only needed a little work. The cottages were once thatched but suffered a fire in 1937 and shingles were used in the refurbishment.

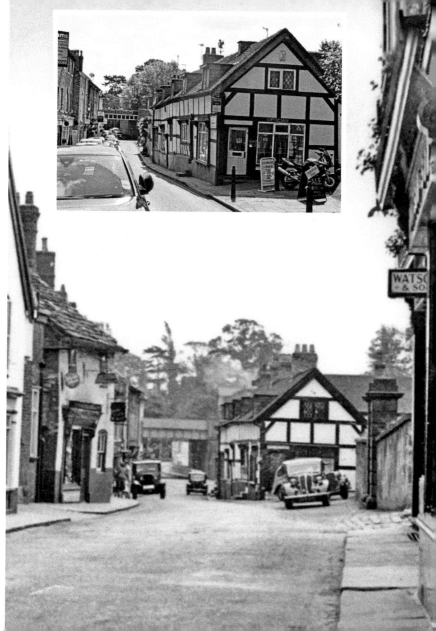

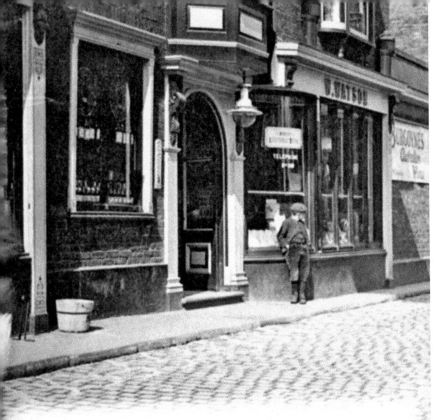

34. SANDING MAY DAY, 1902

Here we have the first old photograph of a practice that I believe is unique to Knutsford. With all ancient traditions, the origins are misted in the fog of time and the same applies in this case. One theory of its origin, which I think highly unlikely, is that when Canute forded the brook and allegedly gave the town its name, he shook the sand from his shoes ahead of a wedding party. Here we see the practice in action prior to the 1902 May Day procession. It also gives us the excuse to take a look along King Street in those far-off days.

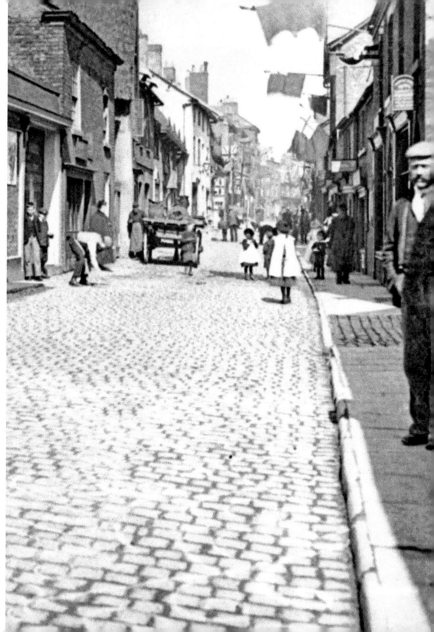

35. KINGS COFFEE HOUSE, 1900–20

Continuing along King Street, we reach the Gaskell Tower and Kings Coffee House, now the Belle Époque restaurant. Originally on this site was the Hat & Feather public house, which was purchased by the eponymous Richard Harding Watt, already mentioned as the man responsible for the Legh Road Italianate houses. This was built in the 'Eclectic Italianate' style at the same time as the Gaskell Memorial Tower and not all welcomed the addition.

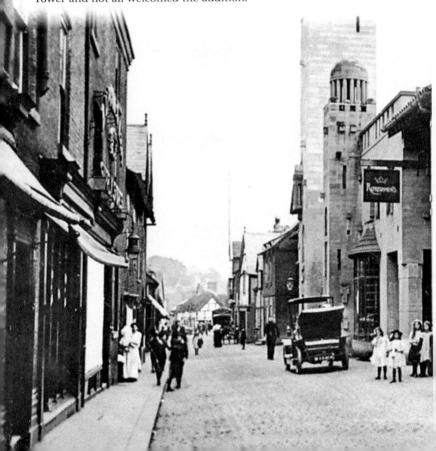

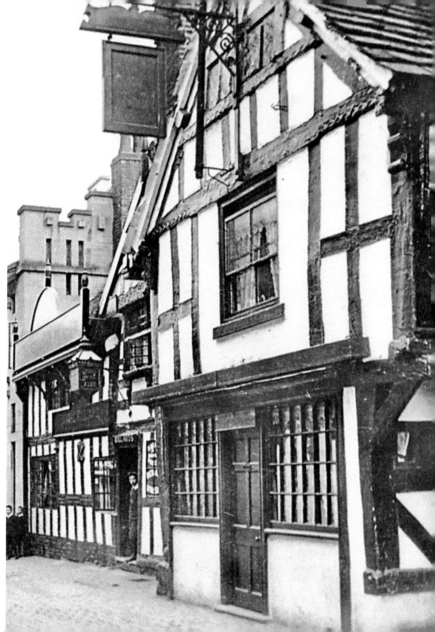

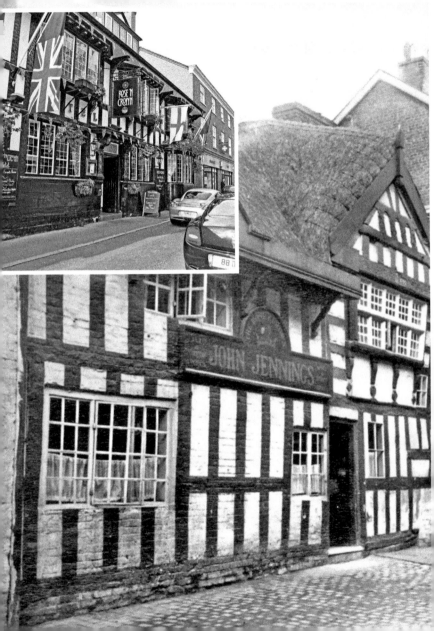

36. ROSE & CROWN, 1890s

Next to the Gaskell Tower is, in the old photograph, the seventeenth-century Rose & Crown public house, which in 1865 was owned by Thomas Lee – a Stockport licensee who also owned other businesses in the town. The pub had been used as dwelling houses and was in quite a rundown state. The 1860 White's Directory shows it as a pub, but a closed one. In 1896 the pub was sold to the Groves & Whitnall brewery; the date '1641' can be seen on a plaque at the front.

The inset image shows a complete rebuild from the ancient pub that once stood here.

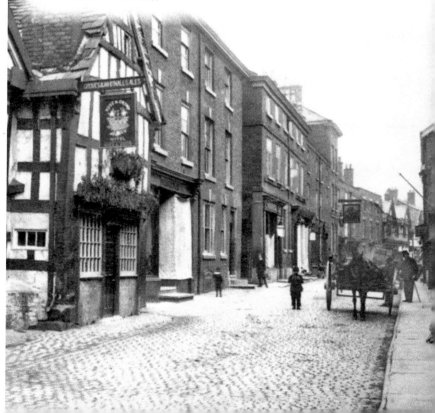

37. KING STREET AND ROYAL GEORGE, EARLY 1900s

Back now for a last look at central King Street, The Royal George and the Gaskell Tower. The Gaskell Tower would have been brand new at this time. Here we get a view of another old coaching inn, the Royal George Hotel. The archway can be seen and at one time the words 'George Hotel' once existed around the curve, then above this the word 'Royal' was applied at a later date. The reason for this was that in 1832 a young Princess Victoria visited with the Duchess of Kent and was so impressed with the service she received that the hotel was permitted to call itself the Royal George Hotel. This ancient coaching inn can trace its origins back to the eighteenth century. This was always an upmarket hotel. One of the coaches that stopped here was the *Bang Up* from London to Liverpool, which stopped at 4 p.m., and the *John Bull* from Chester.

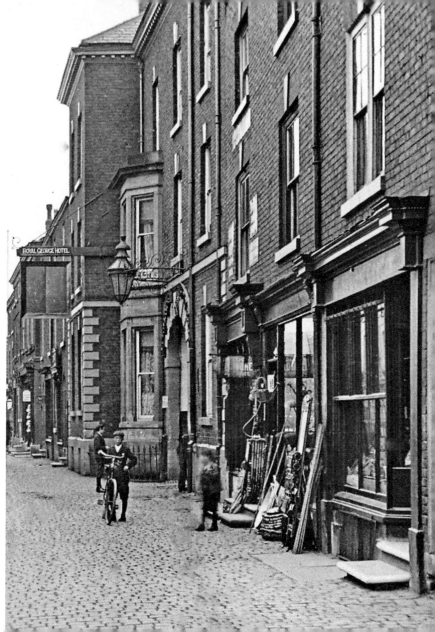

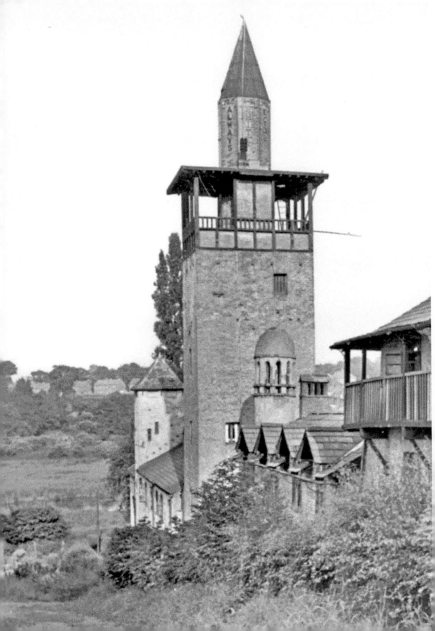

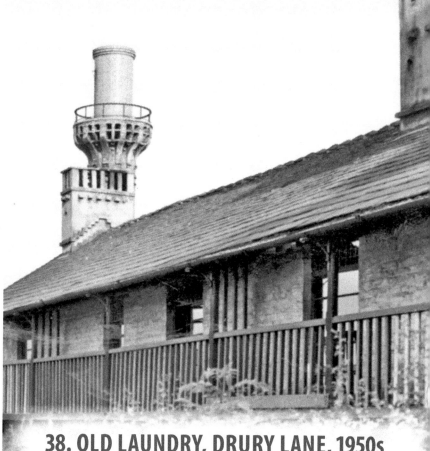

38. OLD LAUNDRY, DRURY LANE, 1950s

We have returned to the work of Richard Harding Watt – one of his earliest creations. Originally a tannery stood here until Watt purchased the land and built this quite fantastic building and the cottages for the workers; it originally had Byzantine domes and a minaret. The building now comprises cottages and is a listed building. It seems that only long after his death did his work become appreciated – it certainly wasn't by everyone during his life.

39. DRURY LANE & THE RUSKIN ROOMS

Here we see the road leading to Watt's laundry and on the right his Ruskin Rooms can be seen, built as a tribute to John Ruskin in his own inimitable style for the people of Knutsford. The building originally had reading rooms and a recreational area. It has also spent time as a fire station, headquarters of the British Legion and a US officers' club during the war. The white building on the right is the old vicarage, which was built in 1693.

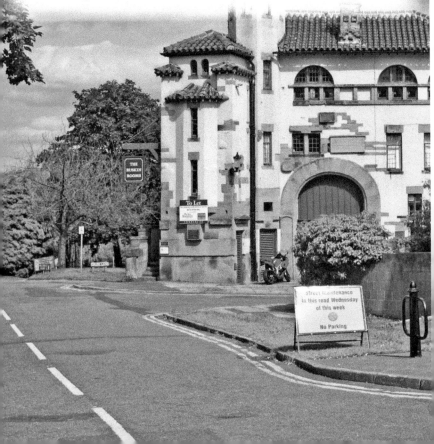

40. TATTON PARK ENTRANCE, 1930s TO 1940s

This spectacular gate is situated at the northern end of King Street and includes the gatekeeper's lodge. The splendid Tatton Hall is through this arch and over the years since the hall was built it has welcomed royalty, dignitaries and some 60,000 troops who trained here as parachutists during the Second World War. The gateway is a Grade II-listed building and the hall itself is Grade I.

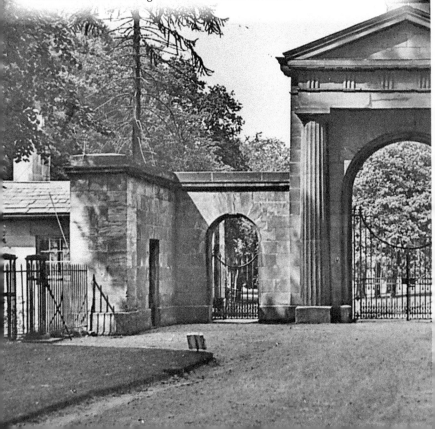

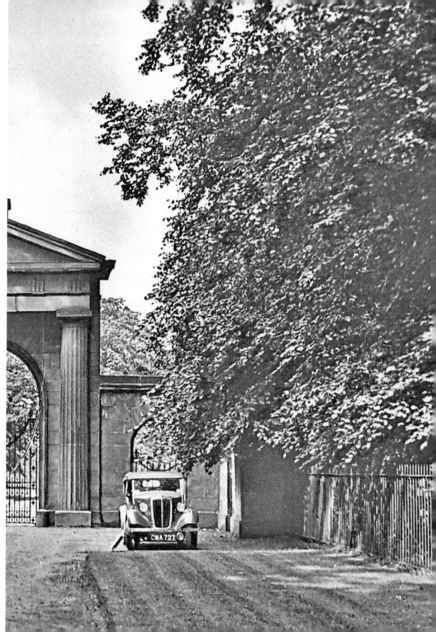

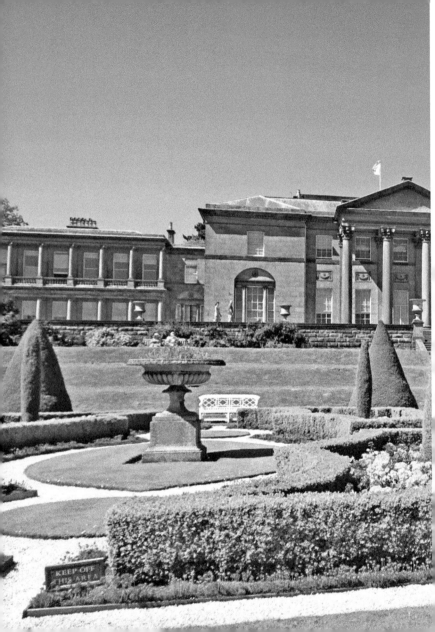

41. TATTON HALL

No history of this ancient town would be complete without mention of Tatton Hall. Tatton Park was owned by the Egerton family from 1598, when it was purchased by Sir Thomas Egerton from his half-sister Dorothy Brereton. They made it their main residence and a new house was built on the site of the present one. During the 1770s, Samuel Egerton commissioned the architect Samuel Wyatt to produce designs for a neoclassical mansion on the present site, the first stage of which was completed after his death in 1791. Upgrades continued through the years and VIPs and the royalty of the time were frequent visitors. The last Lord Egerton was Maurice and on his death in 1958 he bequeathed the house and gardens to the National Trust. Accordingly this beautiful mansion and extensive grounds are open to the public.

As the introduction by the National Trust says, 'If Tatton Park is a jewel in the crown of Cheshire, then the Old Hall is its hidden gem.' The medieval building stands near the disappeared Tatton village, whose humps and hollows show where houses once stood. The site is a 'Scheduled Ancient Monument' and considered an area of significant historical and archaeological importance in the North West. The Old Hall was built at the turn of the fifteenth and sixteenth centuries. The single-storey great hall is still there and, dimly lit by candles and flickering fire, it retains the shadowy atmosphere of its medieval beginnings.

42. TATTON PARK

This park consists of some 2,000 acres of landscaped deer park. It is a very popular visitor attraction with many shows, musical events and of course the North West annual Royal Horticultural Flower Show, which has been held at Tatton Park since 1999. To the south of the hall ornamental gardens on two terraces can be found.

During the Second World War the park was used by parachute regiments as a training ground and had the Parachute Training School situated there. Trainees would jump from specially adapted barrage balloons and also from planes flown from the main school at Ringway, now Manchester Airport. As well as the army, it was used to train the secret agents from the SOE in preparation for jumping into enemy territory. All of this was with the complete co-operation of Lord Maurice Egerton. There is a large limestone memorial in what was the dropping zone within Tatton Park. In all, 429,800 jumps had been made from planes and balloons at Tatton Park and Ringway. (Image courtesy of David Dukesell)

ACKNOWLEDGEMENTS

I would like to thank Linda Clarke of the Chester Records Office for her help in acquiring old photographs and Fred McDowell for allowing me access to his impressive archive. Also Laura Gilling of the Tatton Park Estate for her willing help in obtaining the photographs of the hall and gardens. As usual, I would like to thank my lovely wife Rose for her patience during the time it took to complete the book.

ABOUT THE AUTHOR

Paul Hurley is a freelance writer, author and is a member of the Society of Authors. He has written an award-winning novel and has numerous newspaper, magazine and local history credits. He lives in Winsford, Cheshire, with his wife Rose. He has two sons and two daughters.

Contact: www.paul-hurley.co.uk

Other Books by the Author

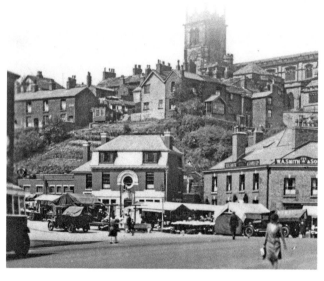

NANTWICH

HISTORY TOUR

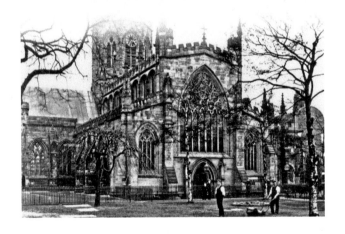

Follow a heritage trail and discover the changing face of Nantwich.

978 1 4456 6872 7
Available to order direct 01453 847 800
www.amberley-books.com